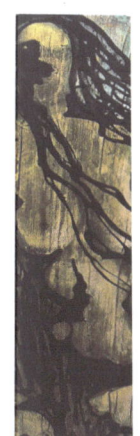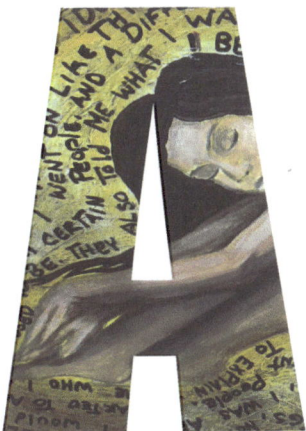

I AM NOT AN EXIT.

ART BOOK

RAFI's Guide To "I AM"

By Rafi Perez

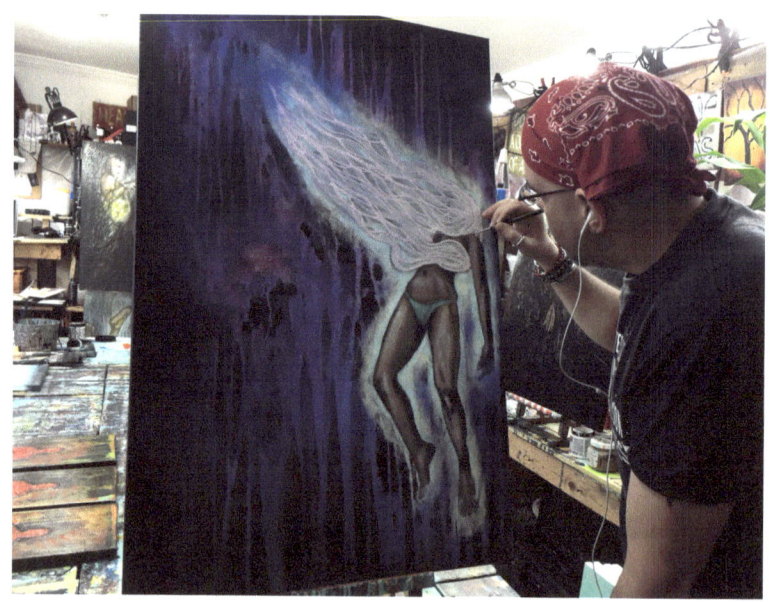

Rafi working on pieces for the show

Copyright © 2017 by Rafi Perez
All rights reserved. This book or any portion thereof may not be reproduced or used in any manner whatsoever without the express written permission of the publisher except for the use of brief quotations in a book review or scholarly journal.
First Printing: 2017
ISBN 978-1-365-79853-5
Rafi Was Here Studios
Pensacola, Florida 32505
www.RafiWasHere.com
www.RafiandKlee.com
Edited By Klee Angelie

RAFI's Guide To "I AM"

ART BOOK

I AM NOT AN EXIT 2017

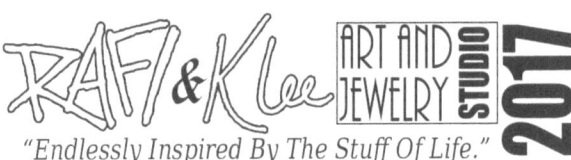

"Endlessly Inspired By The Stuff Of Life."

RAFI & K lee ART AND JEWELRY STUDIO 2017

RAFI's Guide To I AM

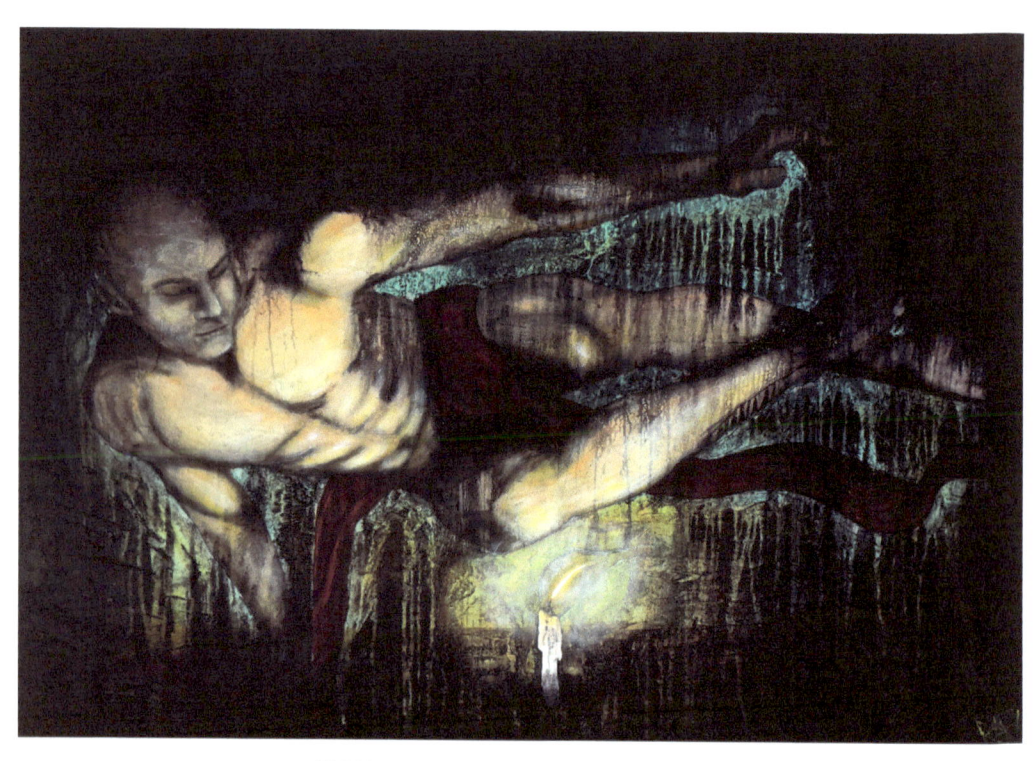

"I Was Born In The Dark" Acrylic On Canvas 55" x 40"

I Was Born In The Dark

I was born in the dark,
I was raised by the dark,
I was part of the dark,
it was my home,
it was where I had become most comfortable,
without ever being comfortable.

Surrounded by darkness,
I look to the light,
the light melts away the darkness,
dripping tendrils of my insecurities,
exposing me to the world,
I become afraid and look away.

I ask the candle flame,
how did you melt away my dark so quickly?
The candle responded,
you were born from the light,
you were loved by the light,
you are the light,
The light is your home.

-Rafi

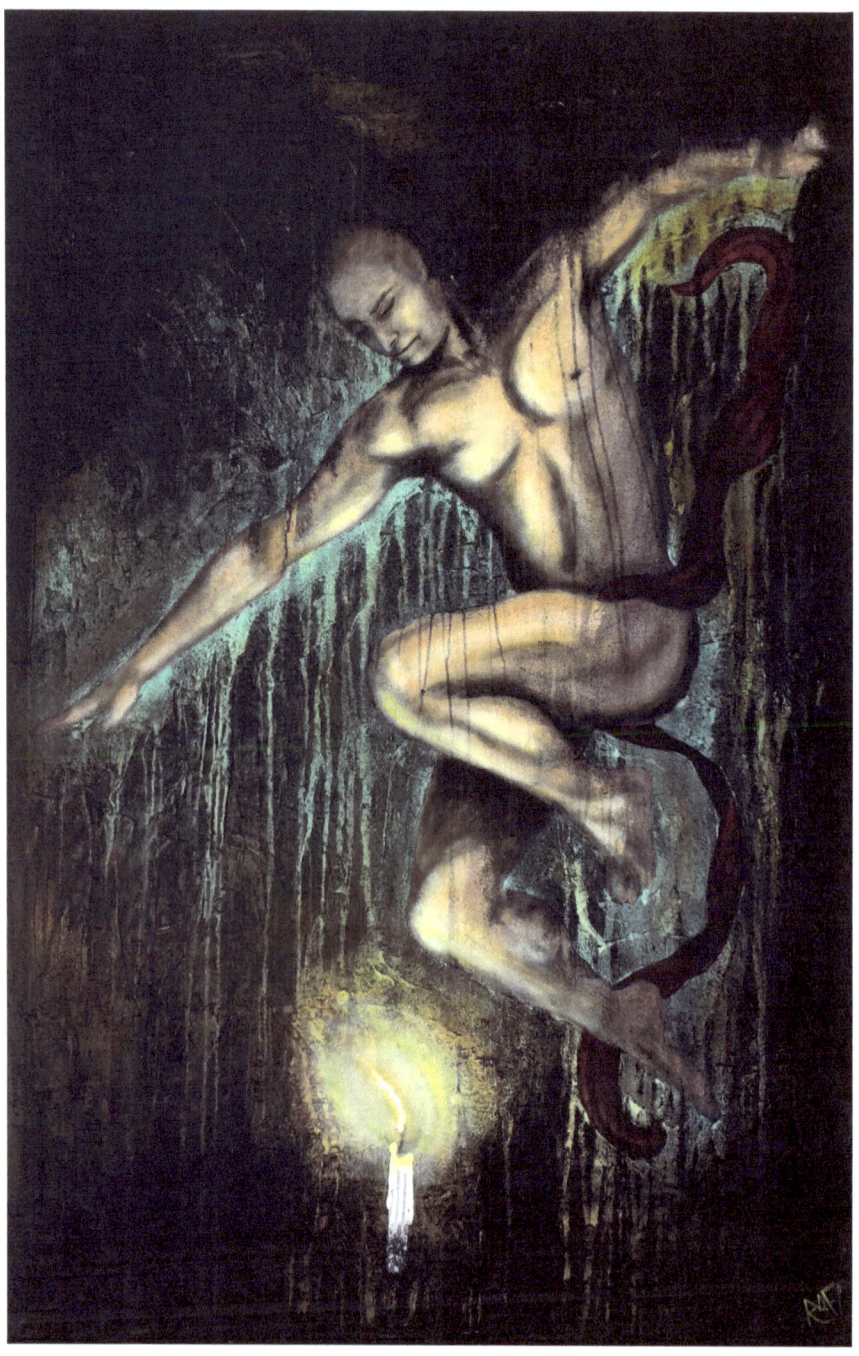

"The Flame Responds" Acrylic On Canvas 57" x 37"

The Flame Responds

Sweet whispers in my ear,
tempts me with the ordinary,
she can predict future tragedies,
she keeps me sheltered in my mind,
she surrounds me in a cold dank of darkness.
In desperation, I ask "Why do you tell me such things?"

The darkness responds,
I am but a reflection of who you think you are.

Am I the darkness?
The light pulls at me,
I dance with the bright flame,
pretending to understand,
when it flickers back and forth.

In desperation, I ask "Why do you tell me such things?"

The flame responds,
I am but a reflection of your light,
you are the source of my flame,
you are the source of my love,
you are the source of my warmth,
you shine so bright in the darkness.

-Rafi

RAFI's Guide To I AM

"Out Of The Flames" Mixed Media

"In the very earliest time
When both people and animals lived on earth
A person could become an animal if he wanted to
and an animal could become a human being.
Sometimes they were people
and sometimes animals
and there was no difference.
All spoke the same language
That was the time when words were like magic.
The human mind had mysterious powers.
A word spoken by chance might have strange consequences.
It would suddenly come alive
and what people wanted to happen could happen--
all you had to do was say it.
Nobody could explain this:
That's the way it was."

-- Nalungiaq, Inuit woman interviewed by ethnologist
Knud Rasmussen in the early twentieth century.

RAFI's Guide To I AM

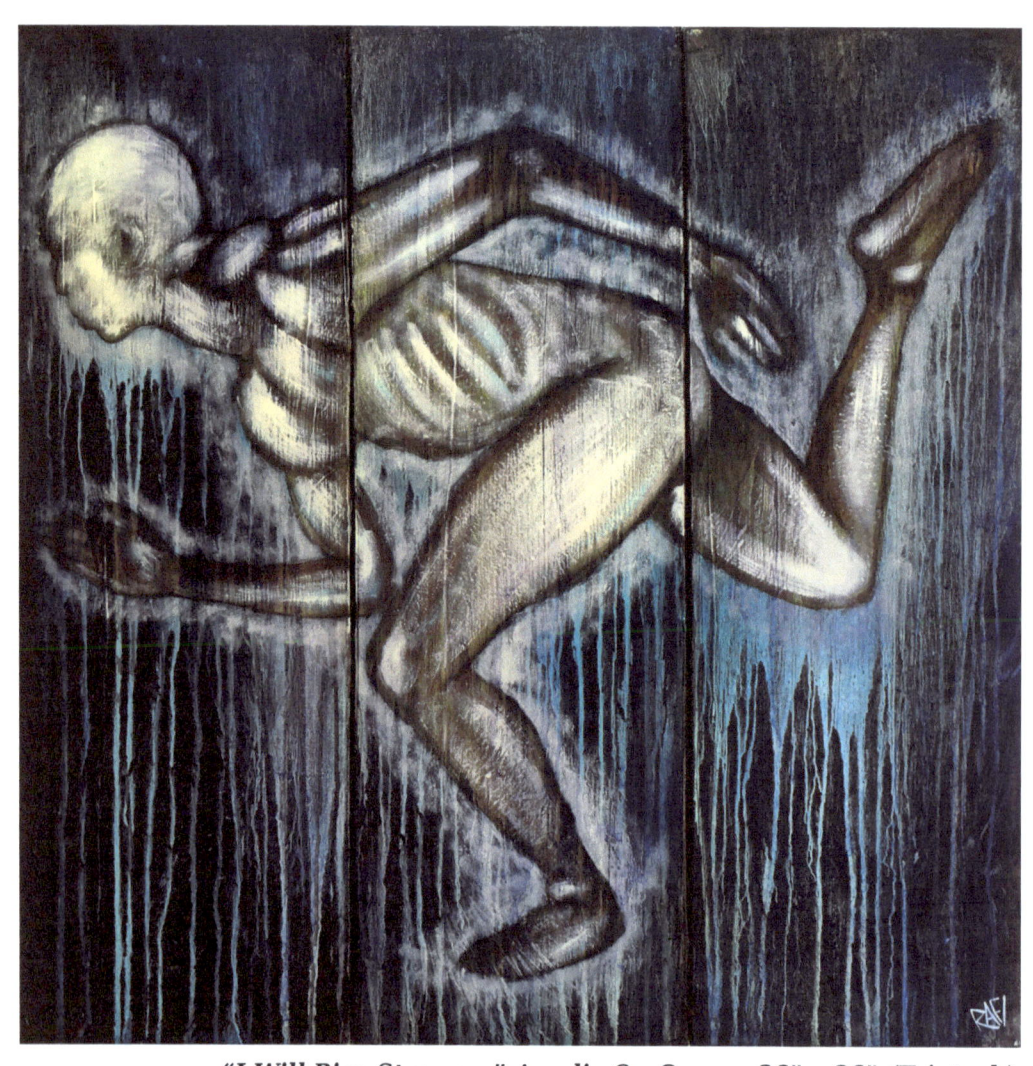

"I Will Rise Stronger" Acrylic On Canvas 36" x 36" (Triptych)

I AM NOT AN EXIT 2017

Dear Candidate,
Thank you for your application to your dream life.
We are sorry to inform you that you have not qualified.
Your lack of motivation, drive, body shape, and talent,
has brought us to the determination that you will not succeed.
We find it in your best interest to quit now,
before you find yourself failing massively.
We do not wish to deal with failure, which you clearly are.

-Sincerely,
Life

Dear life,
I appreciate your reasonable suggestion.
I understand that I may have lacked motivation and drive.
I also understand that I've spent a lot of time criticizing my body,
and feeling like I wasn't talented enough to succeed at anything...
unfortunately, I was brought up to think that was normal behavior.

But, I just realized something... I'm electric... I'm unstoppable.
You see, I've also brought my determination.
The determination to be willing to face failure, again and again.
To not define myself by my failures, but to grow from them.
I find it in your best interest to understand,
although you'll knock me down,
 I will always rise stronger.

-Thanks for that,
Candidate.

RAFI's Guide To I AM

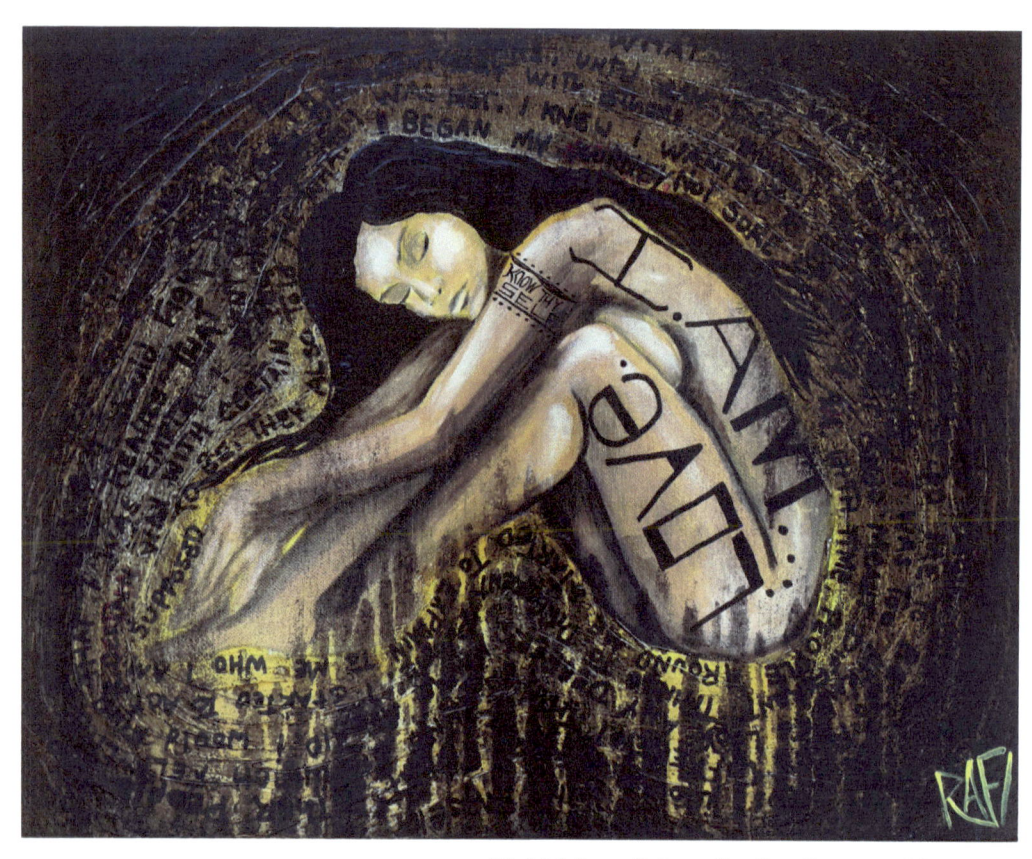

"I AM Love" Acrylic On Canvas 16" x 20"

*One day, I was walking around the yard pondering,
I looked at a rock and wondered if it had feelings,
I looked at the sky and wondered if it was looking at me.
I found myself making up stories about the rock and the sky.*

*I looked around some more, and I found a flower,
within seconds I had a whole story about this flower.
I saw mystery litter in the yard,
and had a story for how it got there.
Pretty much everywhere I looked, I saw stories.*

*I saw the mailman... He's a drug addict,
he probably steals mail.
I saw my car... It's on its last leg,
need to replace it soon.
I saw my neighbors... They probably deal drugs.
I saw my reflection... You are a fraud,
and everybody knows it.*

*I guess, I'm really just a story in my head,
but so is everyone else.
So, if I'm just a story,
does that mean I can tell any story I want?*

I decided with the help of the sky and the rock to tell a different story.

*I saw the mailman...
You're nice, thank you for my mail.*

*I saw my car...
Thank you for getting me around, I really do love you.*

*I saw my neighbors...
Thank you for always being nice to me.*

*I saw my reflection...
I love you... I'm sorry... Please forgive me... Thank you.*

I AM NOT AN EXIT 2017

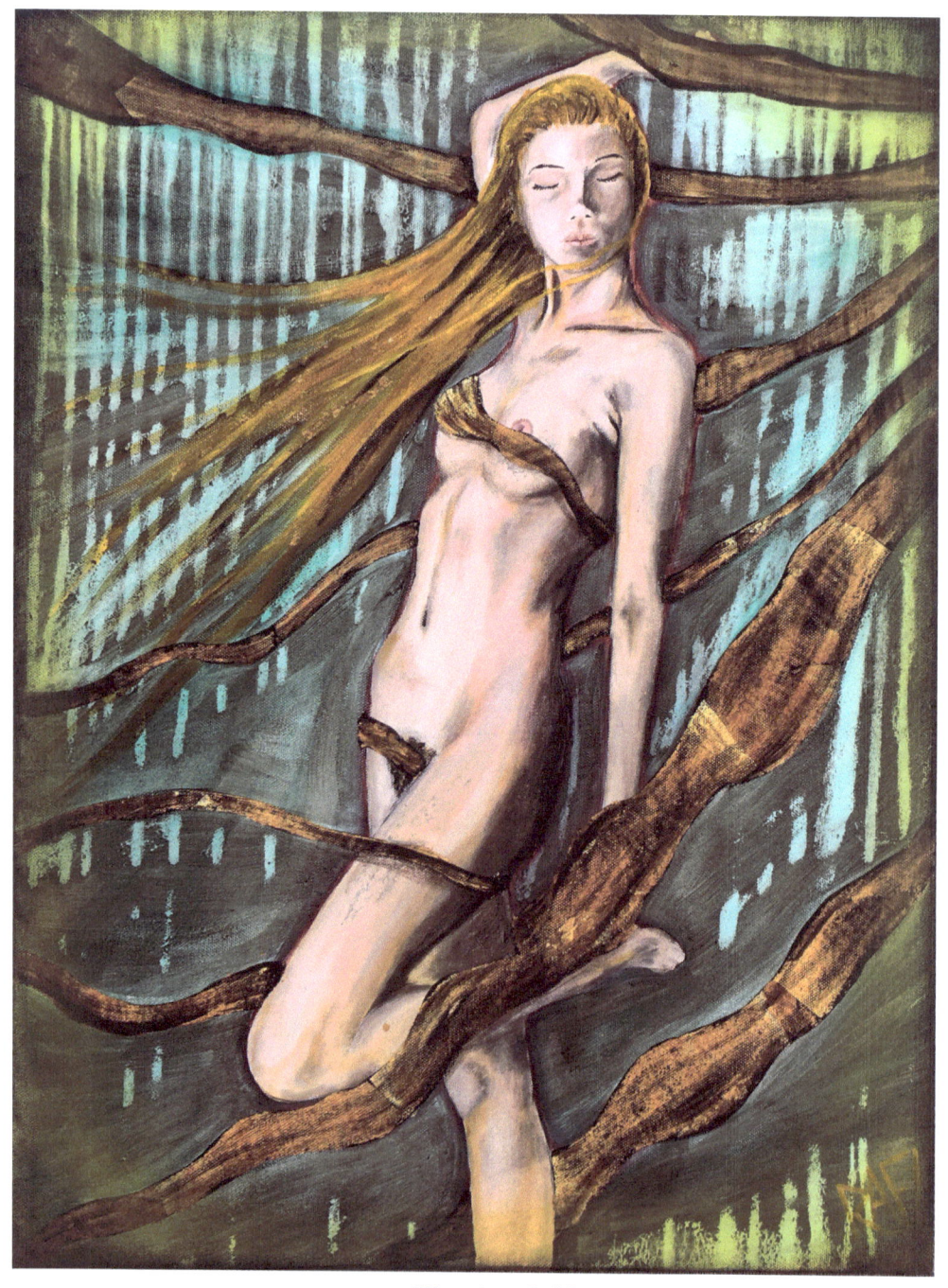

"You Are Gold" Acrylic On Canvas 18" x 24"

"I just don't know how to love" she says,
cheeks red, eyes full of tears.

"You are love" I respond.
*"You are the gold that shines on the earth,
you are the sun that shines in the sky,
you are the stars that twinkle in the night,
you are something astonishingly beautiful.*

*Something burned into my mind,
that is born fresh every day...
Only love can do that."*

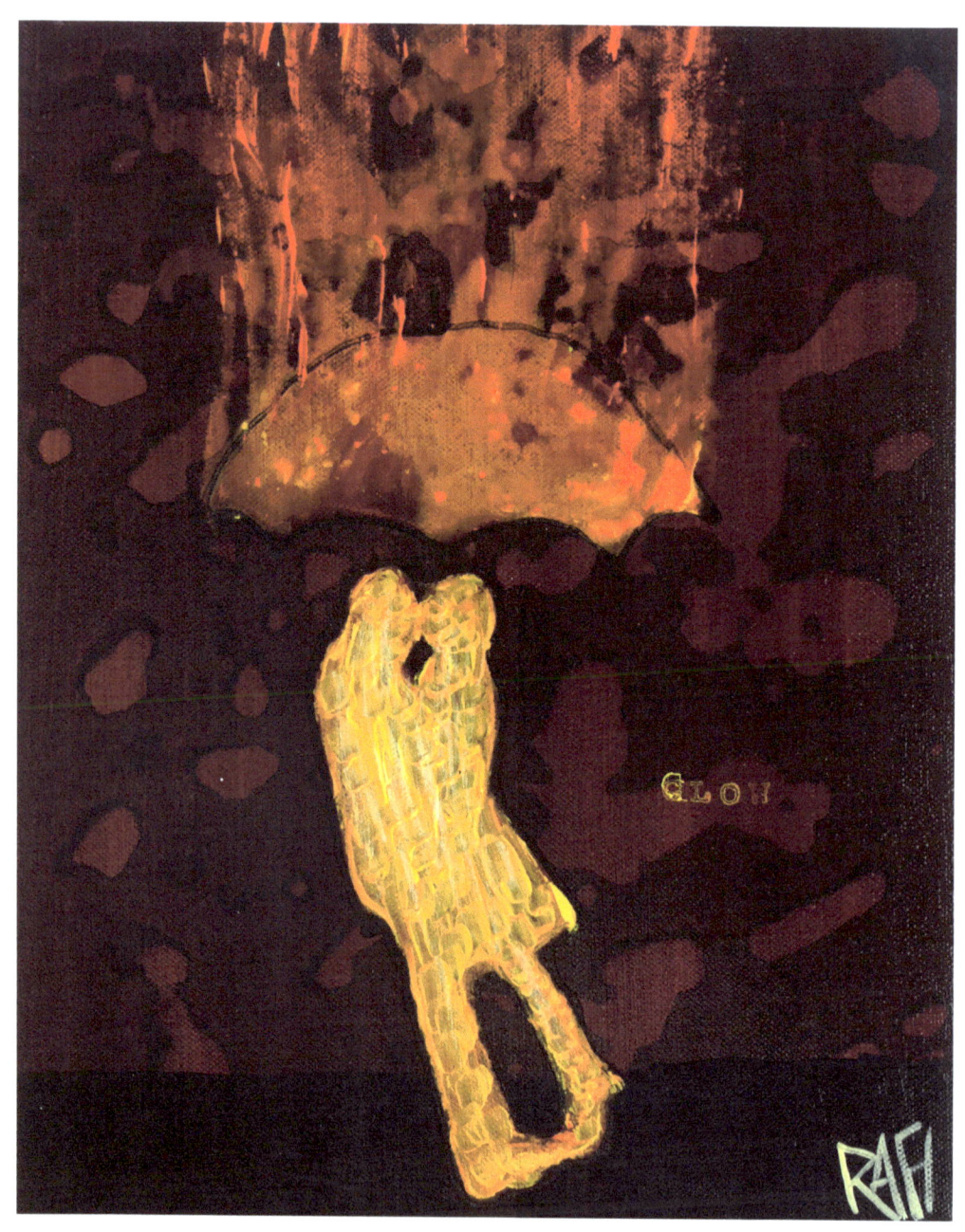

"Glow" Acrylic On Canvas 11" x 14"

Love is like a fire
It can take time to burn bright
It may start out as a spark
And becomes a flame that grows

We can forget to stoke our flame
We can pour water on our passion
We can cover our fire with dirt
We can be left with nothing burning

But sometimes the dark embers
Are still smoldering deep within
It just takes that little spark
To get the fire burning again

The secret is maintaining your own fire
The other person is in charge of their own
Because there is nothing like the glow
Of two bright flames coming together.

--Rafi

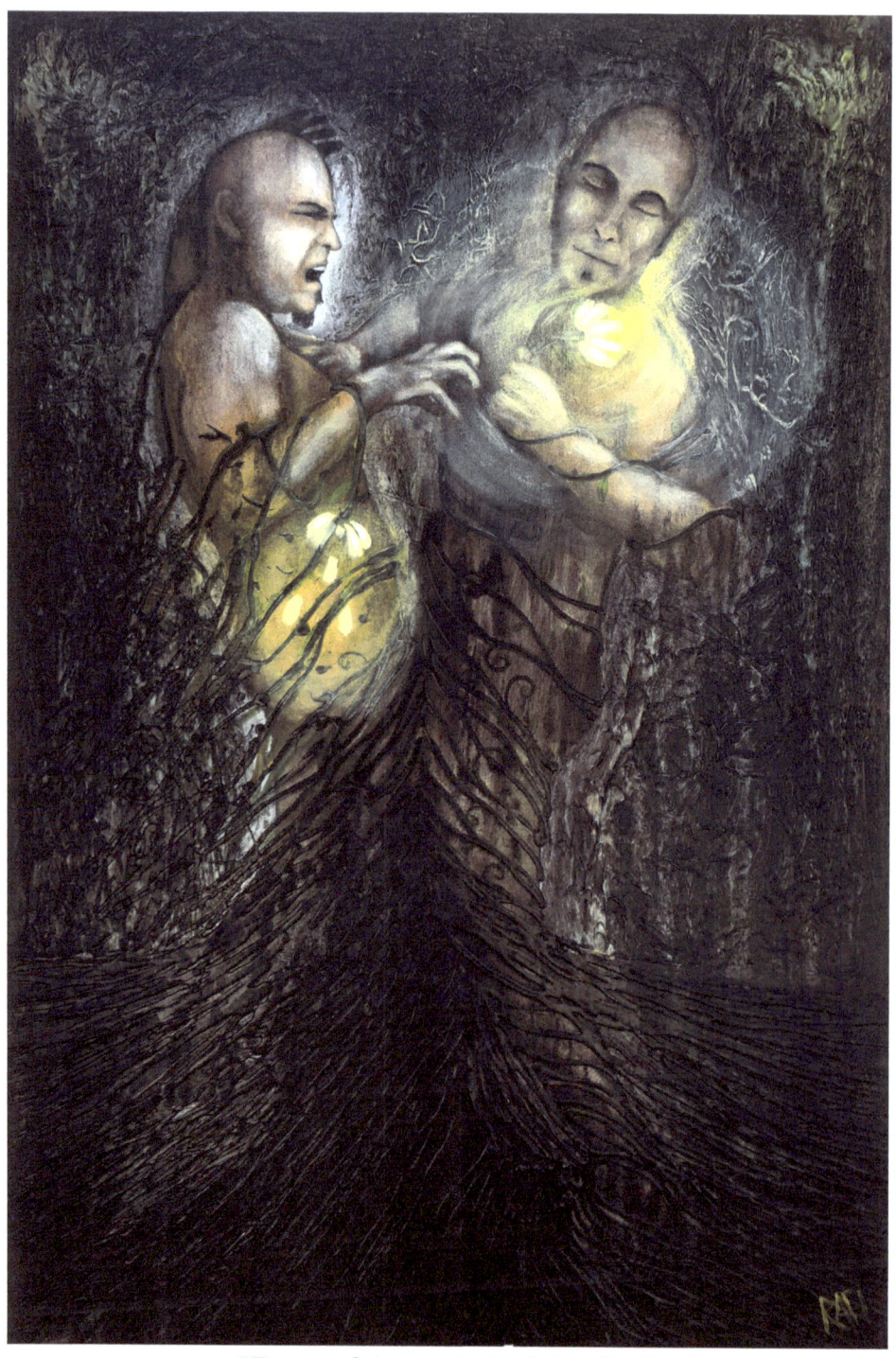

"Envy and Appreciation" Acrylic On Canvas 24" x 36"

Envy and Appreciation

In a distracted world,
I find myself looking at the spoils of another,
wondering if that was supposed to be mine.
Yet, what is mine is mine,
and what is your is yours.
How can I focus on what I really have,
if I am so focused on what you have?
Full of barely controlled chaos,
when you lock your eyes onto what is mine,
I will close my eyes,
focusing, listening, hearing, caring,
being fully in the moment,
living in my gratitude.
For, I can be you,
or I can be me.
I choose love.

--Rafi

RAFI's Guide To I AM

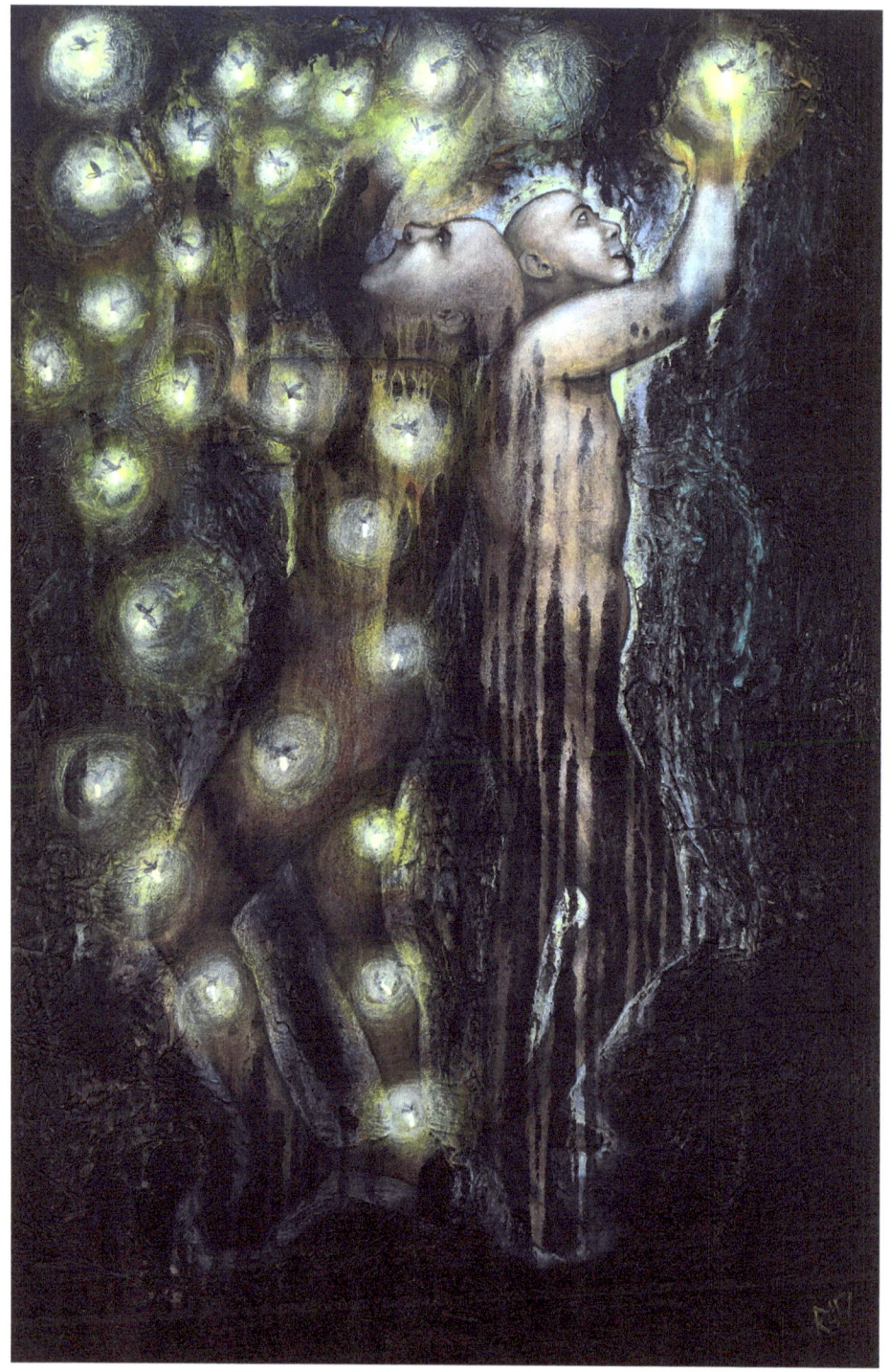

"Lack and Abundance" Acrylic On Canvas 24" x 36"

Lack and Abundance

*Can you see the awesome in those things
that you may take for granted?
A paved road, running water, or a smile.*

*He asked for a car, then complained about
the model.*

*He flies like gods through the air, then
complains about security check in.*

*He has so much, yet he complains about
what he has.*

*If you concentrate on finding what is good,
what is beautiful in every situation,
you will discover that your life will suddenly
be filled with gratitude,
a feeling that nurtures the soul.*

<div align="right">

--Rafi

</div>

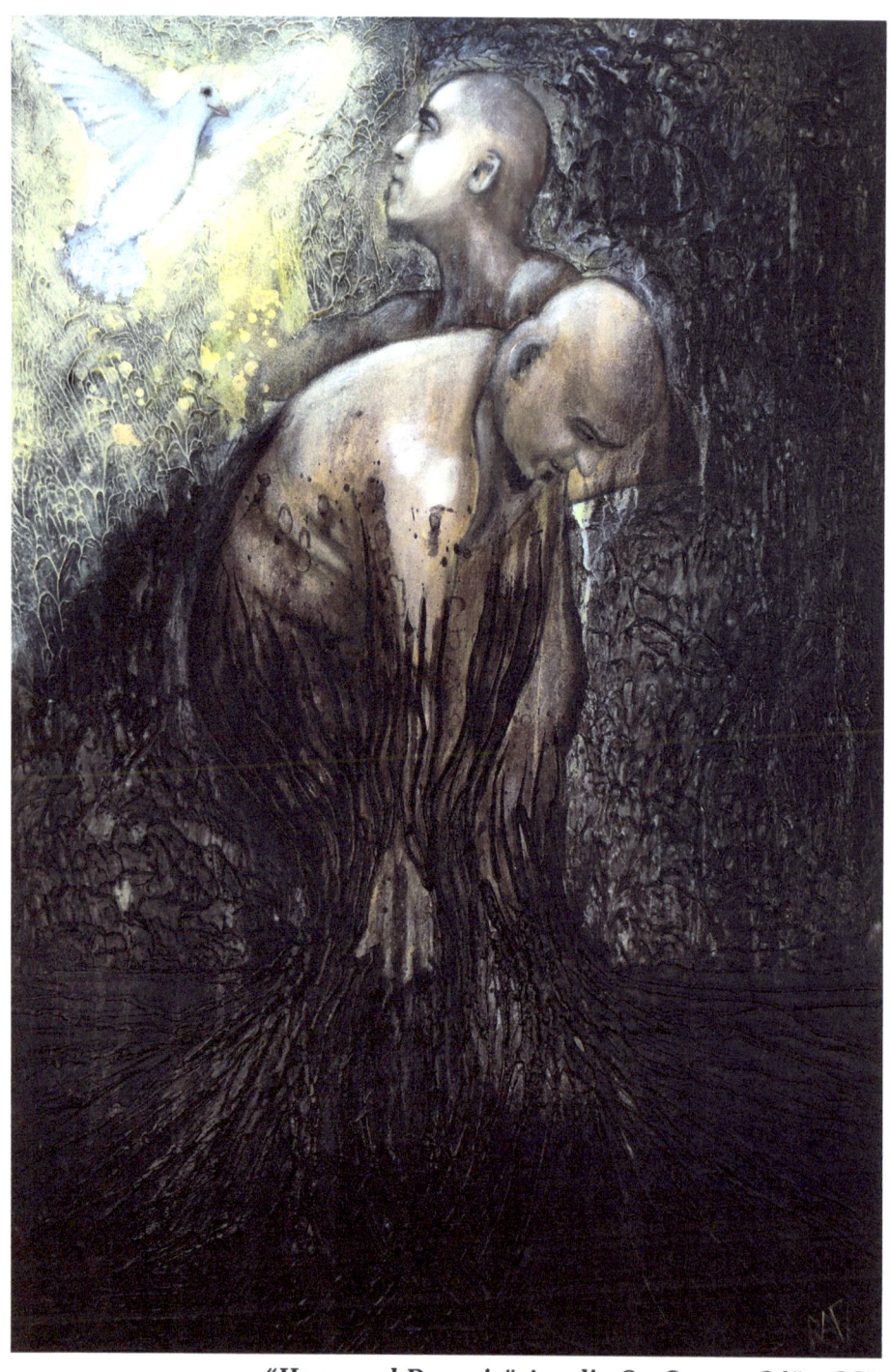

"Hope and Despair" Acrylic On Canvas 24" x 36"

Hope And Despair

I look off into the horizon and I see the ocean,
but it's not actually the ocean because I live by a lake.
The ocean is over four hundred miles away,
I don't know how I will ever see it again.
Again.
Again?
I saw it once already, which means I can maybe do it again,
but I feel so stuck in this place, wrapped tightly by my own fear.
The fear is impossible to remove, and it sticks to everything.
Just the other day, my friend came to my house to talk.
She left a little fear on my couch,
it took a lot of scrubbing to get it out.
That stuff is like tar,
once there is enough of it, something interesting happens.
It turns into despair...
Again.
Again?

We all go through hard times in life.
It's a part of being alive.
There are times we forget our value,
because we are so blinded by negative thoughts.
Somewhere along the road of life,
we become numbed with frustrations and dissatisfaction.
We pull at it and put all our focus on it.

We resist it, we fight it,
we think about it by trying not to think about it,
we try to figure it out,
we try to figure it out.

But life isn't about darkness and sadness,
life is filled with magic and beauty.
Don't try to solve the problem,
look for the beauty that is right under your nose.

--Rafi

RAFI's Guide To I AM

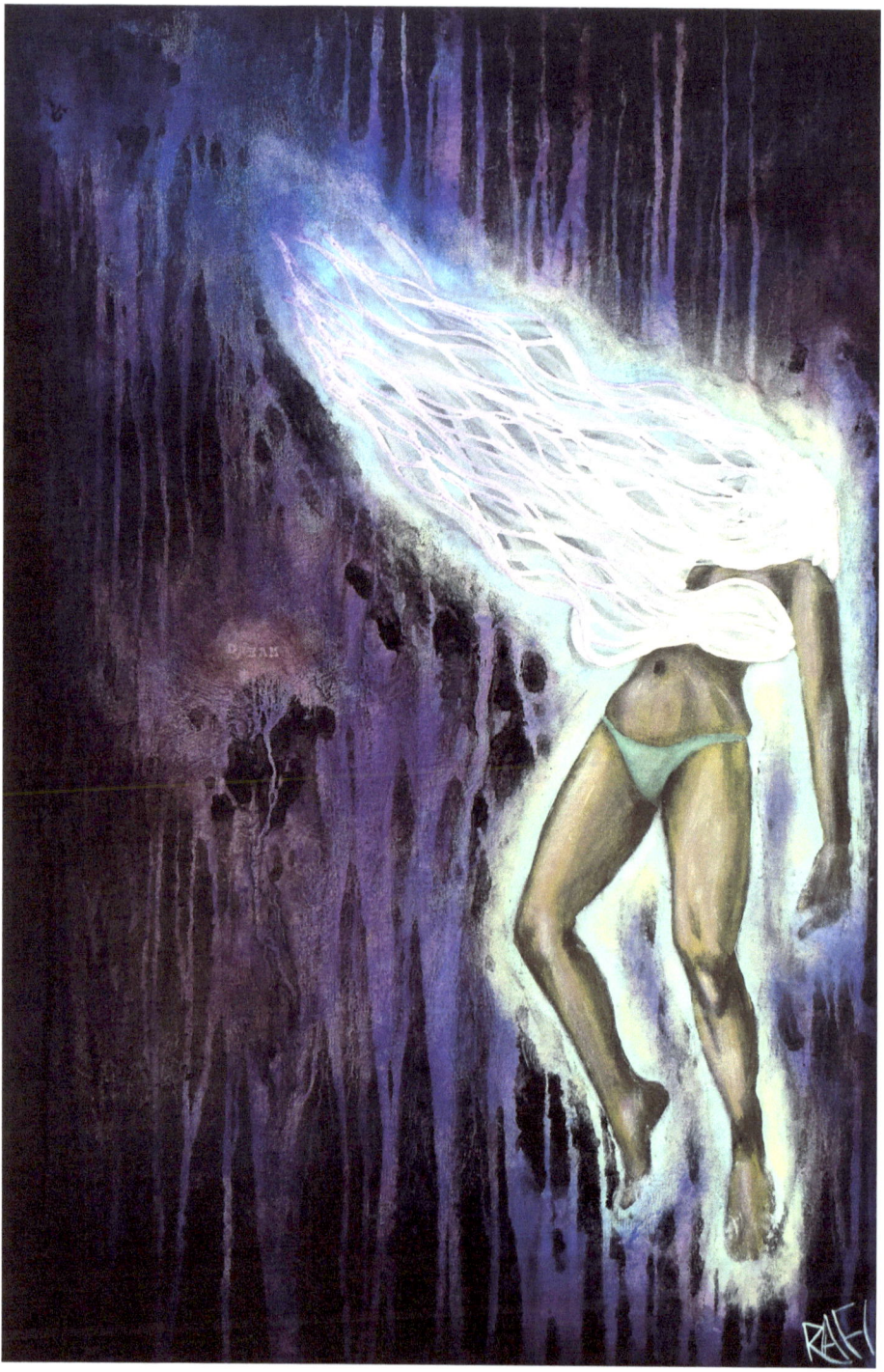

"The Dreamer" Acrylic On Canvas 24" x 36"

The Dreamer

Be a dreamer.
Beauty despite the peril.
The joy in every conflict.

Be a dreamer.
Reach out for the impossible.
What will happen tomorrow?

Be a dreamer.
Live to your own tune.
The tune that only dreamers can perceive.

Be a dreamer.
The world as it should be.
Live in that world.

Be a dreamer.
Wonder and curiosity.
Joy and big smiles.

Be a dreamer.
Dream the moment.
Be the moment.

Be a dreamer.
Paint the colors of your dreams.
The world is your canvas.

--Rafi

RAFI's Guide To I AM

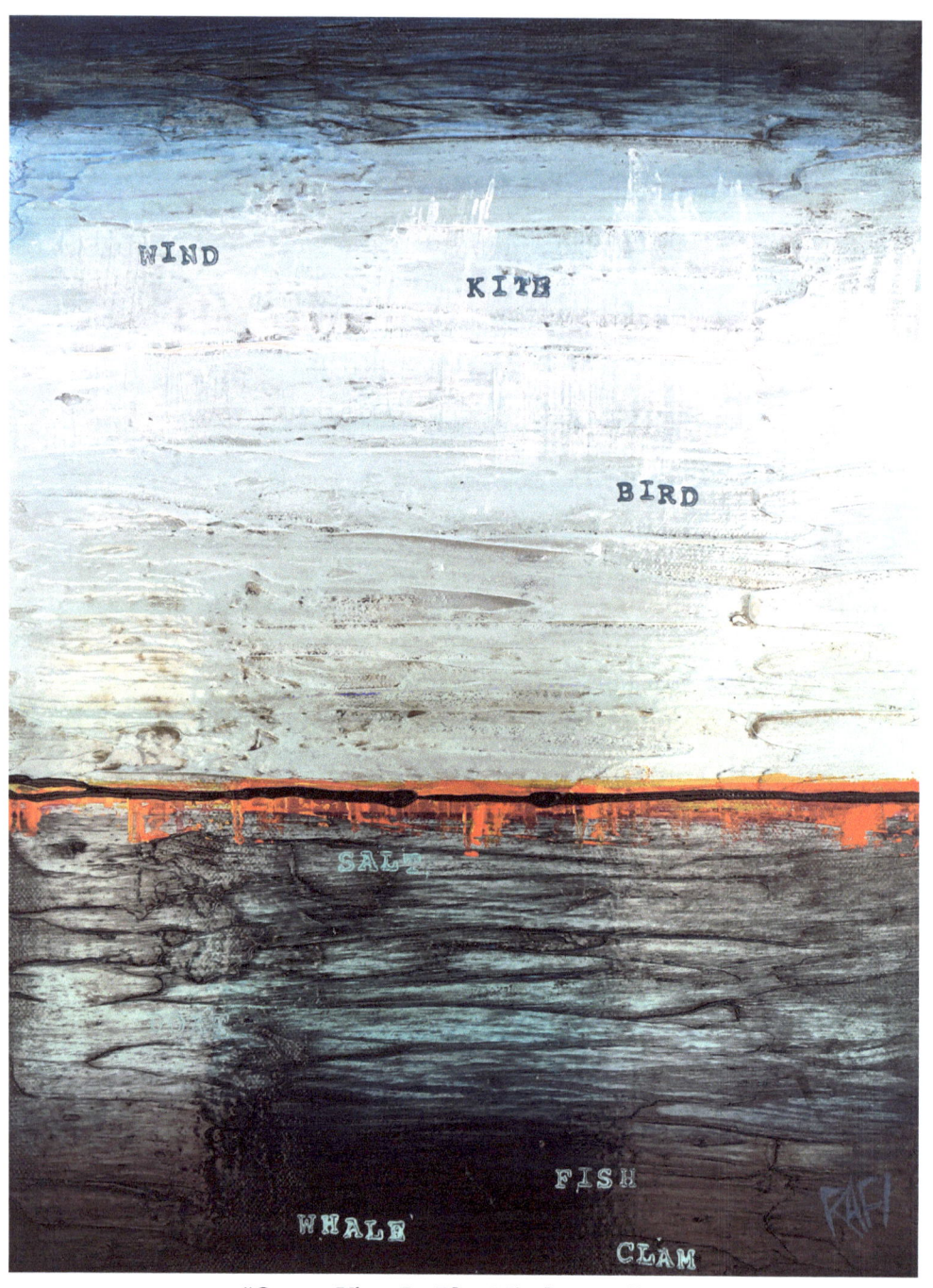

"Ocean View In The Mind" Acrylic On Canvas 12" x 16"

I AM NOT AN EXIT 2017

Boats splash along crashing waves
Sand bites through the wind
She can hear a kite tail flicker
The patter of the seagulls

Words in the mind
Imagination in motion
An experience you can taste
Yet here you are indoors.

--Rafi

RAFI's Guide To I AM

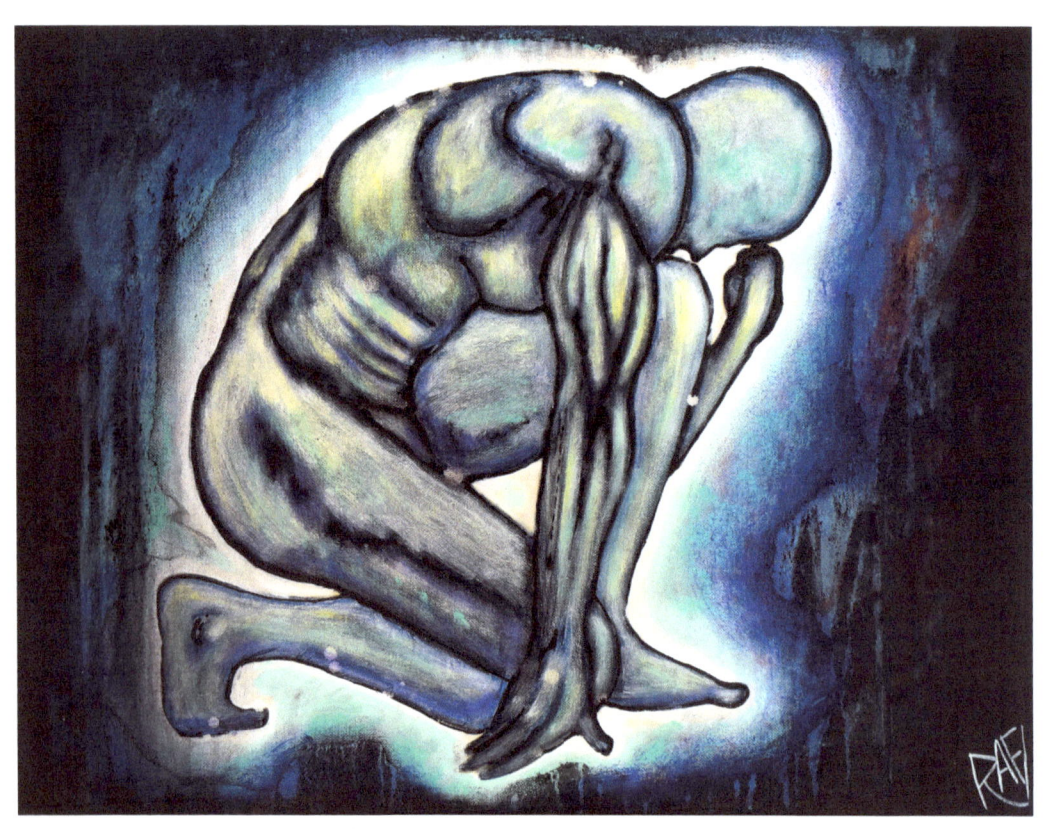

"Internal Universe" Acrylic On Canvas 18" x 24"

I AM NOT AN EXIT 2017

The universe is curled up inside of us,
ever expanding in its beauty.
If only we could see that beauty.
If only we could see that expansion.
If only we could see the stars within,
we would glow like a shooting star.

--Rafi

RAFI's Guide To I AM

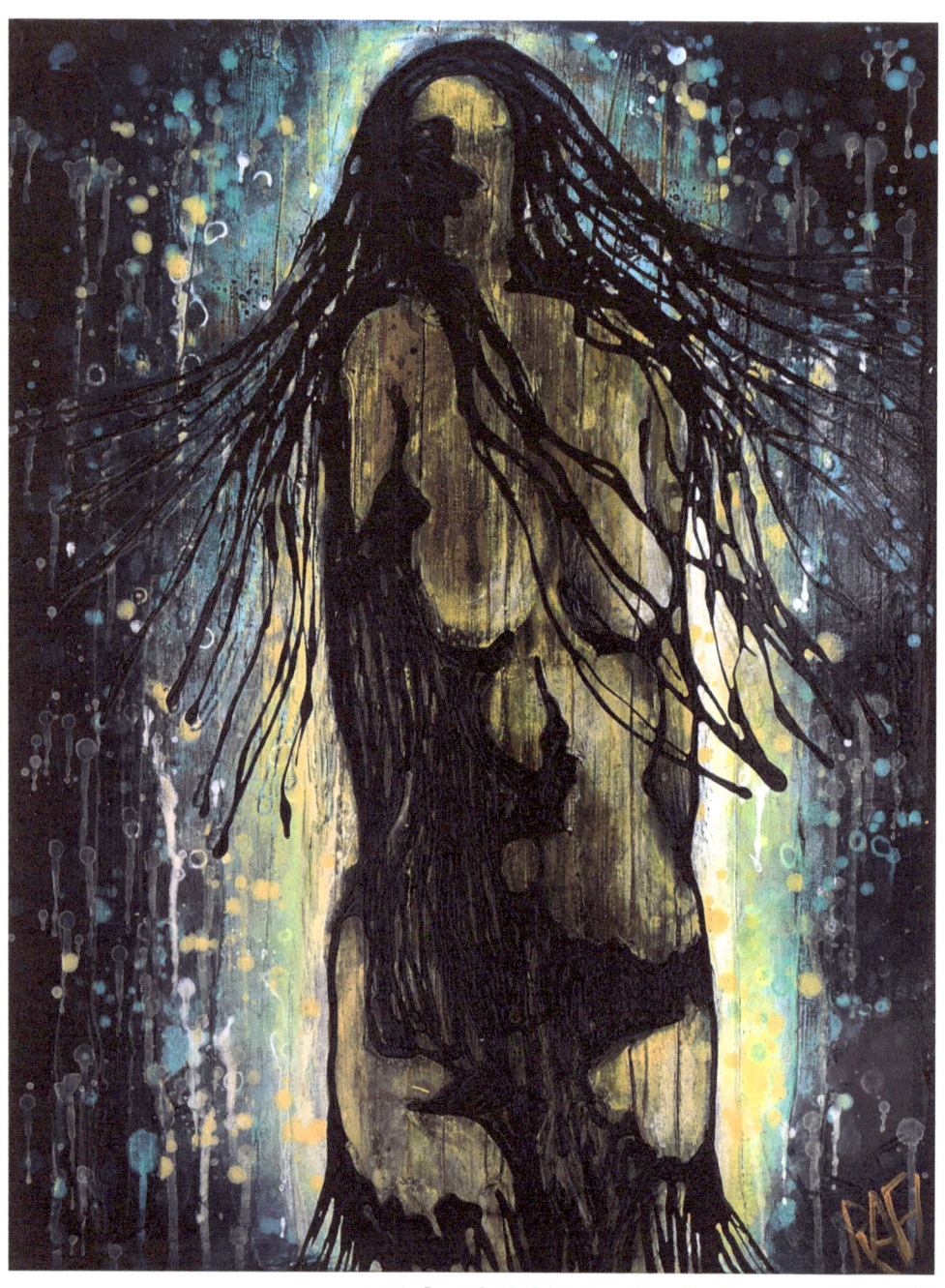

"Made Of Light" Acrylic On Canvas 18" x 24"

I AM NOT AN EXIT 2017

*The other night I looked in the mirror
and I saw myself coming apart,
I exploded into a vortex of light and color,
suddenly I had no recollection of what I looked like.*

All I saw, was light...

All I was, was light...

All I am, is light...

Why would I ever doubt my beauty?

<div align="right">*--Rafi*</div>

RAFI's Guide To I AM

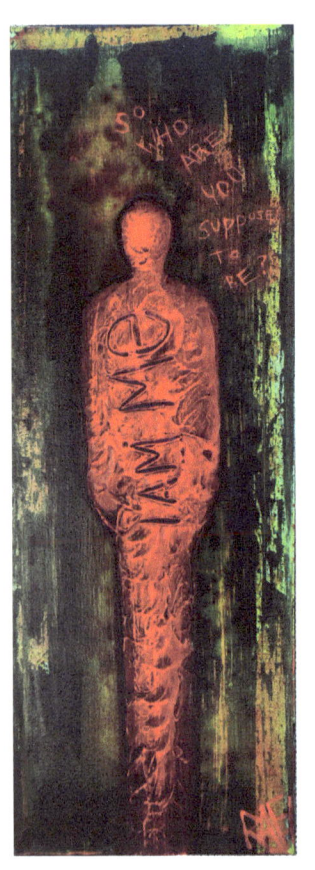
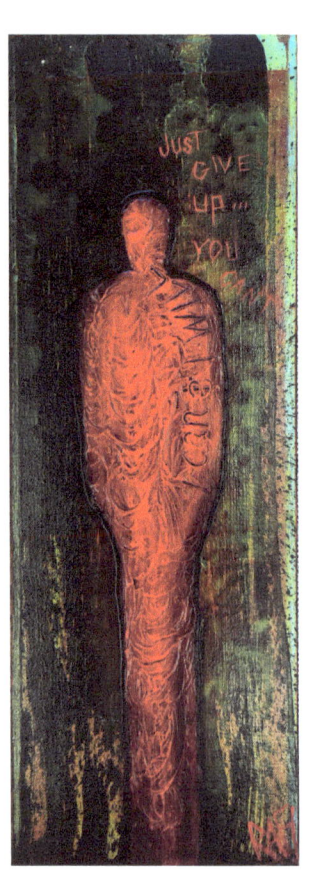
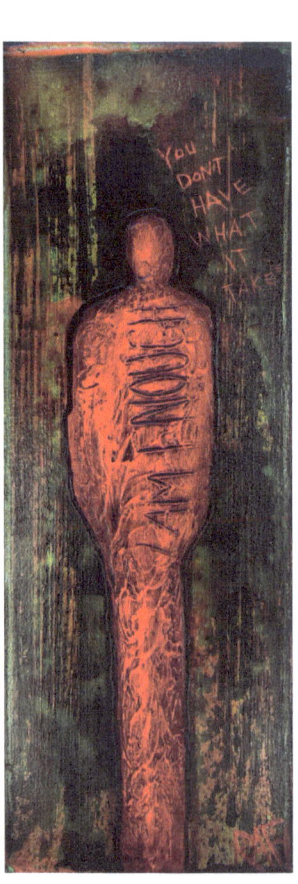

"I Am Me" Acrylic On Canvas 8" x 24"
"I Can" Acrylic On Canvas 8" x 24"
"I Am Enough" Acrylic On Canvas 8" x 24"

I AM NOT AN EXIT 2017

Dear Naysayer,

For as long as I can remember you have always been there for me, though rarely in a positive way. Don't get me wrong, I do appreciate your concern, but I wish you would realize that my life is headed where I want it to go. My way of seeing the world is very different from yours, so your perspective of the way I do things is quite irrelevant. Please understand that for me, the journey is far more important than the destination.

Listen, I know all the hurdles I have to overcome better than anyone, and your negative attitude does nothing to encourage me. The list of concerns you present to me are things that you are worried about, just don't expect me to worry with you.

Ok, I'm just going to say it... I am a grown ass man (or woman) and you are going to have to trust me when I say, I got this. You may know what's best for your life, or what is possible for you, but it doesn't mean that it's best for me.

I do want to thank you though, because you inspire me to prove you so wrong that you will shut that hole in your face.

Sincerely and with love,
A Dreamer.

I hope you discover a journey that will challenge your perception of the world. Explore the mind, and challenge your ideas about self, and the awareness of who you believe to be.

Who Am I?

www.ingramcontent.com/pod-product-compliance
Lightning Source LLC
Chambersburg PA
CBHW041117180526
45172CB00001B/299